Shigetaka Kurita

Emoji

PAUL GALLOWAY

THE MUSEUM OF MODERN ART, NEW YORK

Shigetaka Kurita (Japanese, born 1972) for NTT DOCOMO, Inc.
(Japan, est. 1992). Emoji. 1998–99. Digital image, dimensions
variable. THE MUSEUM OF MODERN ART, NEW YORK. GIFT OF
NTT DOCOMO, INC.

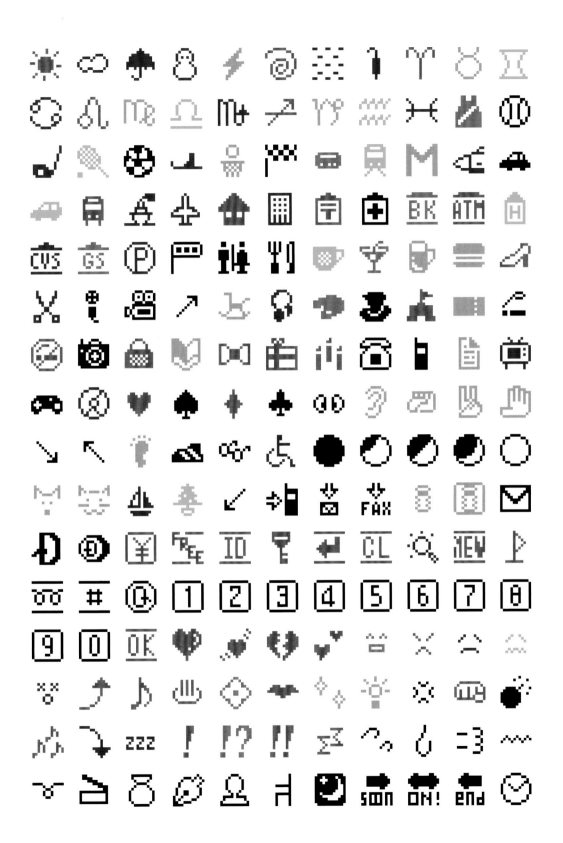

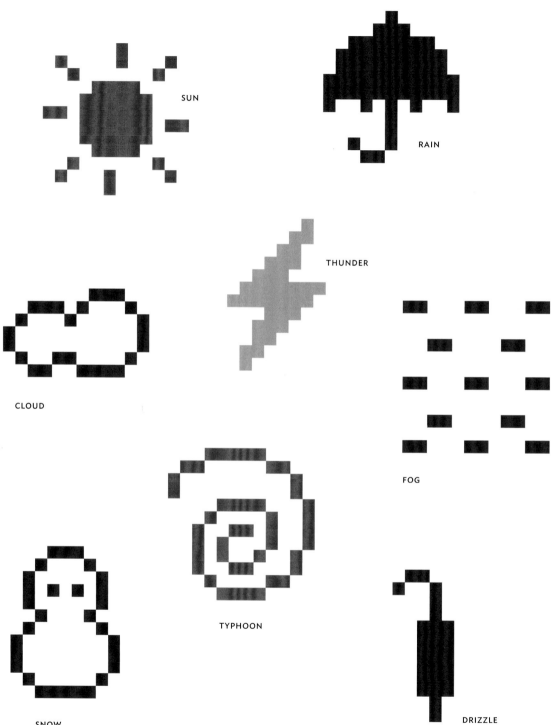

SUN

RAIN

THUNDER

CLOUD

FOG

TYPHOON

SNOW

DRIZZLE

SPORTS

MOTOR SPORTS

GOLF

BASKETBALL

BASEBALL

SOCCER

SKIING

TENNIS

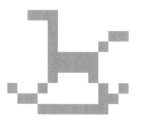

AMUSEMENT PARK

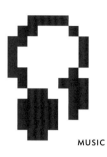

MUSIC

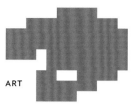

ART

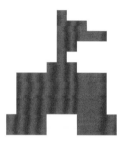

EVENT

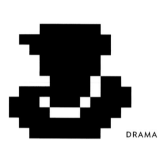

DRAMA

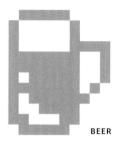

BEER

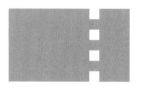

TICKET

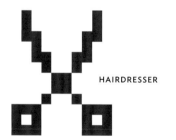

HAIRDRESSER

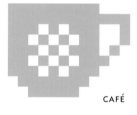

CAFÉ

BAR

FAST FOOD

BOUTIQUE

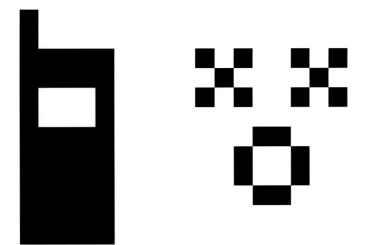

IT'S EASY TO GET THE WRONG IDEA ON THE INTERNET. THERE ARE COUNTLESS opportunities for misspeaking, misreading, misinterpreting, and misunderstanding. Misinformation is ridiculously easy to produce and disseminate, and ideological opponents sneakily exploit this ease in order to undermine each other. But most miscommunication is accidental, especially between generations—nobody *wants* to be misunderstood. Your cantankerous uncle probably doesn't know that HIS FACEBOOK POSTS WRITTEN IN ALL CAPS read as aggressive shouting—he was just going for emphasis. Your mother's wild overuse of ellipses . . . so natural to her . . . read as bizarre unlinked trains of thought . . . removed from the natural rhythm of speech . . . thoughts that trail off . . . wandering into unrelated subjects . . . suddenly shifting to discussing someone's cats . . . and then, inexplicably, tuna casserole—she was just being conversational. And as AI becomes increasingly sophisticated, it becomes difficult to tell the difference between a human customer-service representative responding in a chat window and a disembodied algorithm diffused in the cloud.

When we speak in person we assume a reciprocity of understanding—that we *want* to understand each other—and we rely on physical cues such as eye contact, facial expressions, and tone to reinforce it. This, of course, isn't possible online, where we consist of words and images rather than bodies. The difficulty of online communication arises from the tension between the informal nature of Internet "speech" and the formal and technical elements we use to transmit it: we use the same basic vocabulary and the same keyboard to type a research paper as we do to compose a direct message to a friend on Instagram. Without the support of physical cues, we risk coming across as hollow or soulless or snide; our messages risk becoming as unwelcome as the plague of spam texts, marketing emails, and reminders about expiring car warranties that fill our

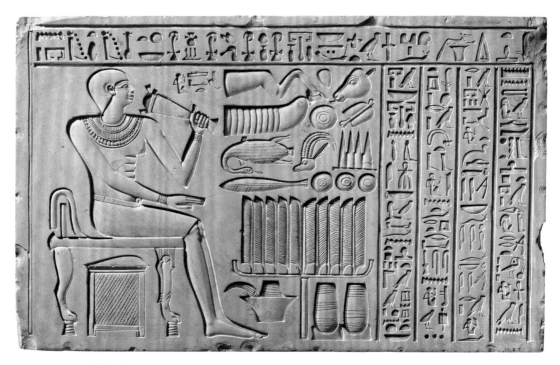

FIG. 1. Stela of the Gatekeeper Maati. Egyptian, reign of Mentuhotep II, c. 2051–2030 BCE. Limestone, 14⁵⁄₁₆ × 23¼ × 3⅛" (36.3 × 59 × 8 cm). THE METROPOLITAN MUSEUM OF ART, NEW YORK. ROGERS FUND

inboxes and voicemail. In the disembodied realm of the Internet we find ourselves constantly needing to assert our humanity.

As the body language of online speech, emoji clarify tone and intent, and they do it economically and efficiently. In a handwritten apology, there is plenty of room to explain a situation and convey true remorse, which is reinforced by the effort of the gesture. In a text exchange, in which brevity is the rule, emoji do some of this work. An emojiless apology might be read as sarcastic or dismissive, leading (in the best-case scenario) to further hurt feelings or (in the worst) to an angry flame war. An emoji can immediately adjust the meaning of the message, accentuating empathy and turning standard phrasing into something more personal. Sometimes a stylized yellow face can convey more than words.

Emoji have only been with us since the 1990s, but they are part of the long history of improvements to human communication, from the invention of writing to the arrival of the printing press to the advent of computers. Their origins

are in the world of Japanese cell phone companies and youth culture, but it was the work of Shigetaka Kurita at the telecom company NTT DOCOMO that turned emoji from a Japanese phenomenon into a global one.

Language is an imperfect form of communication. Although it works well for exchanging factual information, it can falter when things are not so clear cut. In recounting transcendent experiences, we struggle to translate and describe the sublime. Difficult situations, such as condolences, can leave us "at a loss for words." So often are words insufficient that our language contains multiple ways to describe the objects and ideas that resist them: ineffable, indescribable, inexpressible, unspeakable. Thoughts, feelings, and abstract ideas have historically been expressed through forms that depend less on both parties' perfect understanding, such as art and music.

The use of images to amplify, clarify, and enrich text goes as far back as the hieroglyphic texts of ancient Egypt, in which pictures of rulers and gods supported a complex system of writing that was itself based on images and symbols [FIG. 1]. In Europe in the Middle Ages, devotional books were hand-copied by monks and embellished with images and flourishes, sometimes using precious metals, that transmitted their stories to worshippers who could not read. These objects also became the prized possessions of wealthy patrons.

One of the most significant advances in written communication was the addition of the tiny symbols that guide how we read sentences. We take punctuation for granted—indeed, it is almost invisible—but it is critical. Consider the difference between the following texts:

> I like cooking, my family, and pets.

> I like cooking my family and pets.

Without the help of punctuation, we insert our own pauses and breaths into texts, especially when reading aloud, which can dramatically alter their meaning. This was true for readers in ancient Rome, who had to intuit the rhythm and intention of written texts made up of uninterrupted streams of words in capital letters; Cicero, in the first century BCE, insisted in *Orator* that the cadence and ending of sentences should be determined "by the constraint of the rhythm" rather than by prescribed breaks or inflections. This reading method fell out of practice with the rise of Christianity, when absolute fidelity to devotional texts became central to worship. To prevent interpretive phrasing on the part of the reader, monastic scribes used punctuation marks that are the forebears of what

ARIES

CANCER

LIBRA

TAURUS

SAGITTARIUS

CAPRICORN

GEMINI

LEO

SCORPIO

VIRGO

PISCES

AQUARIUS

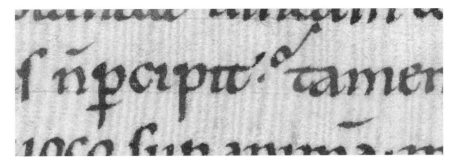

FIG. 2. Page from *Augustinus: Opera* manuscript (detail). French, 11th century. BURGERBIBLIOTHEK BERN. A *punctus interrogativus* appears at the end of the sentence.

we use today: a *punctus* for a pause or short breath, a *punctus interrogativus* for a question, and a *diple* for quotations [**FIG. 2**]. The copyists abbreviated frequently occurring words by joining the letters in them, as in & ("and," for the Latin *et*) and @ ("at," for *ad*).[1] Improvements to written language have continued into the present, in the ongoing refinement of typefaces and letterforms to increase legibility, for both leisurely absorbing the complex contents of a printed page and quickly deciphering a freeway sign at seventy miles per hour. Keyboards now accommodate the alphabets and scripts of a host of written languages (not forgetting the fractious world of computer-programming languages), along with the diacritical marks that signal pronunciation and inflection. Spelling in some languages has been standardized through official oversight, as French is by the Académie française; in English, one of the few major languages to lack such a regulatory body, various movements to reform spelling have been put forward since the sixteenth century. These developments have made clearer writing possible, narrowing the gap between what is intended and what may be understood.

In the late nineteenth century L. L. Zamenhof, an ophthalmologist in Warsaw, went further, proposing an entirely new language for both writing and speaking, which he hoped would eliminate the frictions that arise in a multilingual world. "Were there but an international language," he believed, "all translations would be made into it alone . . . and all nations would be united in a common brotherhood."[2] Zamenhof's language, which he called Esperanto, was designed to be simple to learn, with few rules and clear logic. Although it did not bring about the global harmony its inventor had envisioned, Esperanto still has its adherents, and you can study it on the language-learning app Duolingo. Another attempt at a universal written language was the Austrian philosopher Otto Neurath's visual system ISOTYPE (International System of Typographic Picture Education), which he developed from 1925 to 1934. It was intended as a "helping language" made up of commonly comprehended symbols that

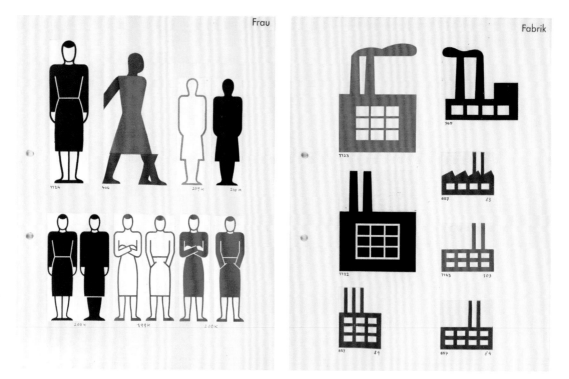

FIGS. 3, 4. *Frau* (woman) and *Fabrik* (factory) pages of the Isotype Picture Dictionary, IC 4/1. c. 1930. OTTO AND MARIE NEURATH ISOTYPE COLLECTION, UNIVERSITY OF READING, ENGLAND

would augment written texts [**FIGS. 3, 4**]. "Words make division," Neurath wrote, "pictures make connection."[3]

The standard shapes proposed by ISOTYPE and other systems became a popular method of making ideas and information readily intelligible. In 1940 ISOTYPE-style figures appeared in Average Day at the Museum, a graphic for The Museum of Modern Art's annual report that presents the young institution as an energetic hive of activity, with viewers in the galleries, administrative staff in the offices, and patrons in the rooftop lounge [**FIG. 5**]. Communication design—the visual distribution and display of information—is just one part of MoMA's history as an evangelist for modern design. This history has included polemical architecture exhibitions proposing efficient, affordable, and innovative methods of building; competitions producing daring new directions for furniture and graphics; and exhibitions on Good Design traveling throughout the United States to educate the public on the potential for everyday objects to functionally and aesthetically improve its environment. The potential for design to improve our facility with computer interfaces, a field known as interactive design, has been explored in exhibitions, and works that have addressed these challenges—like emoji—continue to be added to MoMA's collection.[4]

AVERAGE DAY AT THE MUSEUM

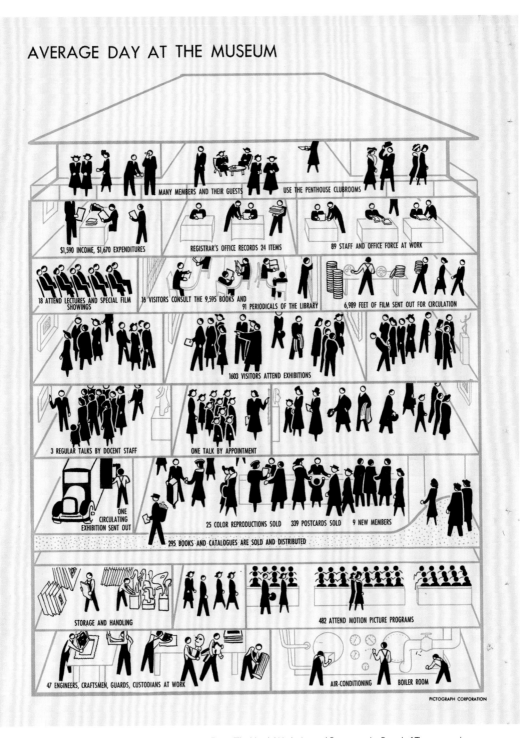

FIG. 5. Average Day at the Museum. 1940. From *The Year's Work: Annual Report to the Board of Trustees and Corporation Members of the Museum of Modern Art for the Year June 30, 1939–July 1, 1940.* Graphic by the Pictograph Corporation. MOMA ARCHIVES, NEW YORK

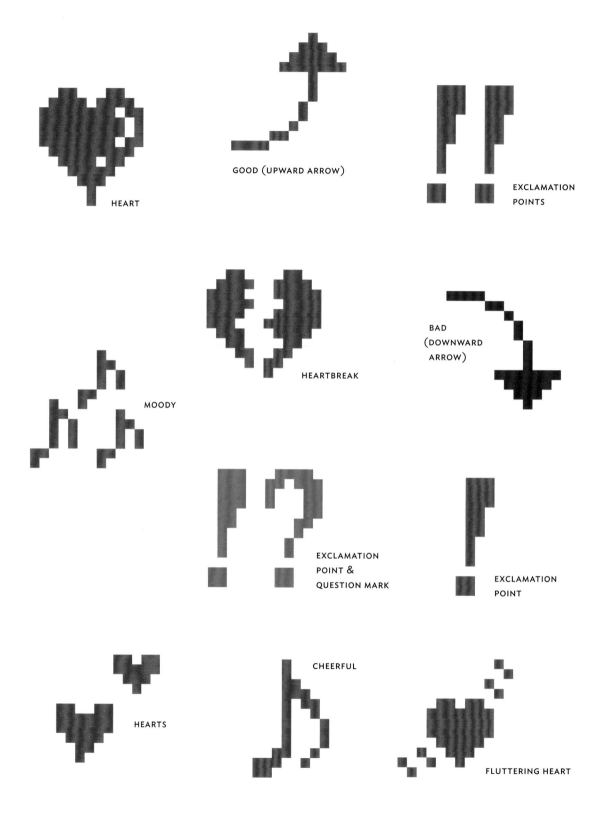

HEART

GOOD (UPWARD ARROW)

EXCLAMATION POINTS

MOODY

HEARTBREAK

BAD (DOWNWARD ARROW)

EXCLAMATION POINT & QUESTION MARK

EXCLAMATION POINT

HEARTS

CHEERFUL

FLUTTERING HEART

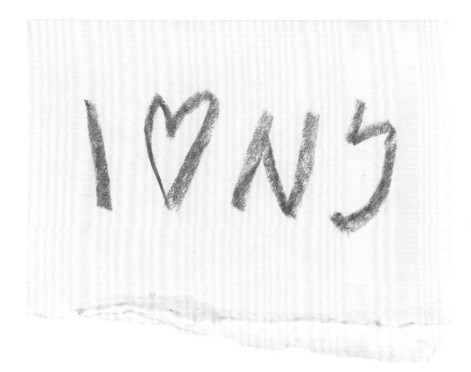

FIG. 6. Milton Glaser (American, 1929–2020). I ♥ NY concept sketch. 1976. Ink and tape on paper envelope, 2⅞ × 3⅝" (7.3 × 9.2 cm). THE MUSEUM OF MODERN ART, NEW YORK. GIFT OF THE DESIGNER

One such work is the original sketch for Milton Glaser's I ♥ NY logo **[FIG. 6]**. It was commissioned in 1975 by the New York State Department of Commerce as part of a push to increase tourism and repair the city's image, which, in the 1970s, was in steep decline during an ongoing state of deterioration and decreasing population. His rebus distills a hopeful sentiment in a stunningly straightforward manner, using only a pronoun, a transitive verb, and a place name; the heart symbol replacing the word "love" simply and beautifully asserts the humanity of the "I." The logo is now a global icon and has been endlessly copied, adapted for other locales and purposes, and splashed across tourist tchotchkes. To our contemporary eyes, it looks more like a besotted text message than an advertising campaign; nevertheless, the logo's arrival at a moment when New Yorkers desperately needed a boost of pride and the enthusiasm that greeted it illustrate the power of a single symbol to profoundly alter meaning, and even collective identity.

In the beginning, online communication changed and adapted organically, according to the needs of users rather than by design. As correspondence moved away from the more discursive template of letters and postcards— first in the short form of emails and then in the shorter forms found in BBS

messaging, Usenet newsgroups, chat windows, and text messages—each new platform produced conventions of communication suited to the increasingly small spaces for text and the increasingly short response times that became the norm, as well as evolving its own vocabulary. In the 1980s and '90s, the early days of public enthusiasm for the Internet, useful phrases were shortened to acronyms (IMHO, LOL, BRB); neologisms (spam, troll, glitch) personalized and enlivened the content of messages, creating social codes and in-jokes that only devoted users could decipher. To further modulate mood and tone, users turned to their keyboards to create symbols that could be seamlessly inserted into text. Emoticons—a combination of "emotion" and "icon"—are faces assembled from standard typographic characters: smiling, crying, angry, and many others.

$$:) \quad :'-(\quad >:($$

Although emoticons remain popular, typing them out requires effort on the part of the sender—especially when composed on a smartphone, currently the input method of choice for younger generations—and imagination on the part of the receiver (a sideways face will always read oddly compared with a correctly oriented one). The larger character set necessary for typing in Japanese afforded a greater range of expressive symbols, leading to the emergence of the more intricate kaomoji (picture faces). Like emoticons, they are laborious to compose, but they are still in use today, among them the perennial favorite of the bemused, the "shruggy."

$$ ¯_(ツ)_/¯ $$

With the arrival of mobile phones capable of accessing the web, brevity in messages, chats, and emails became even more critical. The severe technical constraints of the devices (including the slow process of typing out messages on a number pad) and the wireless networks (which could only handle small amounts of data transfer) required that character counts be tight. Cell phone companies in Japan, the leaders of innovation in this field, recognized a market for a service that would allow for the insertion of small symbols in line with text. The birth of emoji was at hand.

Emoji—e for picture plus moji for character—were the perfectly logical result of the entwining of Japanese culture and communications technology in the 1980s and '90s. During this period, a new craze had swept the country: the pager or pokeberu (for Pocket Bell, the name of the device) [FIG. 7]. These small devices were enthusiastically adopted by the public and at first were used as

intended, as a means of contacting people who were away from their landline telephones when a quick response was critical—calls to doctors, for example (and, notoriously, drug dealers). Operation was simple: you dialed a recipient's pager and punched in a callback number, which the pager displayed on a small screen; the recipient then located a phone and returned the call. But Japanese teenagers and young adults, many of whom were constrained by anxiety about direct contact, found a way to creatively exploit this function, using pokeberu as a novel way to avoid speaking on the phone. (The origins of so-called tele-phonophobia have been much debated, although it does not seem to be con-fined to Japan. A similar anxiety would emerge in the West in the twenty-first century: if you want to make a typical Millennial squirm, have their parents call them out of the blue.)[5] Young people lined up at public pay phones to call their friends' pagers, but instead of leaving callback numbers, they sent strings of digits that were codes for full messages—numbers mapped to syllables, with combinations that added up to words and phrases. This practice tapped into the Japanese penchant for *goroawase* (wordplay), which is richly fed by the homophones, double entendres, and fine distinctions of Japanese script and pronunciation. But what sounds like simple wordplay was in fact complicated and required practice to master; for those conversant in the emergent code, 39 meant "thank you," 0906 meant "I'll be late," and 14106 meant "I love you."[6] Pokeberu and the language they engendered marked a watershed moment: you could receive texts through the air, wherever you were. Texting a *berutomo* (bell

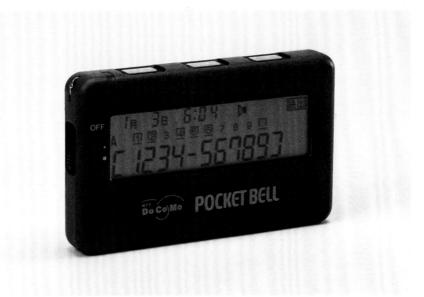

FIG. 7. NTT DOCOMO Pocket Bell pager, late 1990s

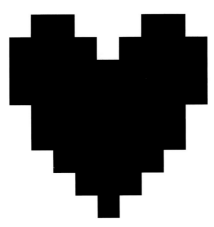

FIG. 9. Heart symbol for the NTT DOCOMO Pocket Bell pager, 1995

friend) was, for many Japanese teenagers, as all-encompassing an activity as endlessly checking social media feeds today.

At the center of the pager craze was the telecom giant NTT [**FIG. 8**], which emerged after the privatization of the state-owned Nippon Telegraph and Telephone in 1985—a breakup analogous to that of the US equivalent, AT&T, a decade before. The new entity moved into the mobile-communications business, creating the company now known as NTT DOCOMO (a homonym for "anywhere" in Japanese). In addition to being one of the largest providers of pager services, it was at the forefront of technical innovation in the highly competitive field of telecommunications. In 1995, seeking an edge over its rivals, the company released a pager with a new feature: a heart symbol that could be added to the numerical messages by punching in a specific number code [**FIG. 9**].[7] This was the first appearance of what would eventually be called an emoji, and, as in Glaser's logo of twenty years earlier, the heart immediately and powerfully humanized the messages it accompanied.

The popularity of the loveable heart character among berutomo suggested a market for devices with broader capabilities, and NTT DOCOMO's competitors took notice. Suddenly, a race was on to offer new features, resulting in a flurry of new products. Among them were pagers that could display text in addition to numerical codes, pagers that could send as well as receive, and, finally, cell phones that could send emoji, the first of which—the model DP-211SW (1997) from J-Phone—featured a messaging service with ninety small pixilated symbols. Although J-Phone's character set preceded NTT DOCOMO's by two years, it had little impact: the device was expensive, and the symbols could only be sent between DP-211SW users.[8] In the end, the heart character proved far more influential than J-Phone's extensive set of emoji, but both demonstrated the need for a service that accommodated a richer form of communication.

PHONE

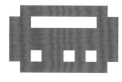

PAGER

MEMO

TV

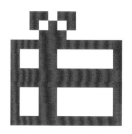

PRESENT

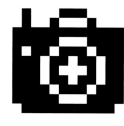

RIBBON

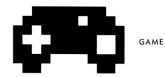

GAME

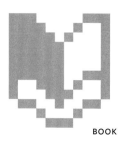

BOOK

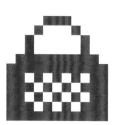

BAG

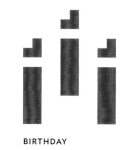

CAMERA

MOBILE PHONE

CD

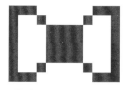

BIRTHDAY

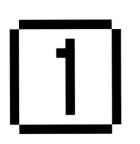

ONE

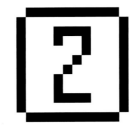

TWO

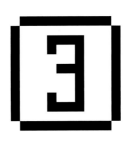

THREE

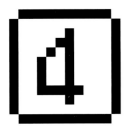

FOUR

FIVE

SIX

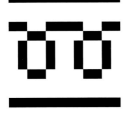

SEVEN

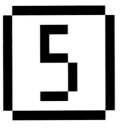

EIGHT

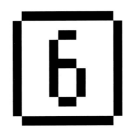

NINE

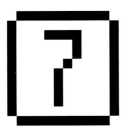

FREE DIAL

ZERO

SHARP DIAL

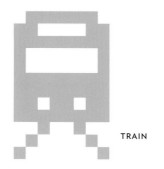

TRAIN

SUBWAY

BULLET TRAIN

CAR (SEDAN)

BUS

CAR (SUV)

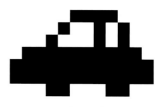

SHIP

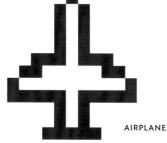

AIRPLANE

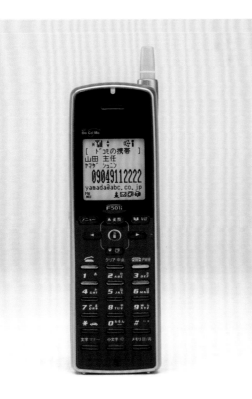

FIG. 10. Model of the Digital Mova F501i HYPER, the first cell phone with i-mode capabilities, 1999

NTT DOCOMO was already at work on a solution. Like many tech companies at the time, it wanted to capitalize on the ways in which the Internet was changing how people organized their lives, communicated with friends, and, of course, made spending choices. Some companies had focused on devices that performed multiple functions, such as the Personal Digital Assistant (PDA)—a handheld device that could be used for taking notes, organizing contact lists, and, in later versions, sending and receiving messages. Apple's Newton (1995) and the PalmPilot (1996) were two of the most influential. But because of the PDA's high cost and limited integration with desktop computer–based networks, they appealed to a small, affluent, business-oriented audience. NTT DOCOMO, as a national carrier, was aiming at something with much broader appeal, and so, instead of focusing on a single device, the company decided to create a network service that would be available for many devices: a portal to the Internet via cell phone [**FIG. 10**]. Through it, users would be able to check their bank balances, search for restaurants, reserve train tickets, and email and message other network users, all the while being served advertisements to influence their purchases. "If we can devise a method of providing information," said Takeshi Natsuno, one of the company's executives, "we'll also create

a completely new infrastructure for distributing information and ads, and one that cannot be achieved using existing media."[9] This is, of course, the ad-sales business model that defines today's Internet.

For two years a team of NTT DOCOMO engineers, project managers, designers, and developers worked feverishly to create i-mode, a service with a set of features that would function in an environment of tremendous restrictions. Cell phones in the late 1990s had weaker processors and less memory than desktop computers, and the wireless networks they accessed were constrained by weak transmission infrastructure and small radio-frequency bandwidth; the devices were thus far less capable of sending and receiving data than their hardwired equivalents. Compared with today's smartphones—the tiny supercomputers that we are accustomed to carrying around in our pockets—early cell phones were positively primitive, even in Japan, which was at the leading edge of innovation. Creating a system allowing access to the Internet for such devices meant simplifying wherever possible, especially in data transmission, a key consideration for both the user, whose data usage was metered and billed accordingly, and for the system accommodating voracious downloaders. The team knew the messaging service would be key to i-mode's popularity and, in order to save on both character count and the volume of data transfer, sought ways to summarize the content of texts. Inspired by the success of the heart character in 1995 and the potential demonstrated by J-Phone's experiment, the team decided to include emoji.

In 1998 Shigetaka Kurita, a young designer, set about creating a large group of symbols for use in the messaging service. He brought a youthful perspective to the i-mode team: his love of tech predated his time at NTT DOCOMO—he had been an avid user of pokeberu, a passionate video gamer, and, earlier in his career, a pager salesman. These experiences greatly informed his work, so that even as he became more experienced, he still believed that his strength was "the ability to see things from the perspective of an amateur."[10] Another of his strengths was envisioning and predicting the behavior of users, both novices and experts, which is crucial for the design of a successful interactive object or service; an interface that works against intuitive behavior can prove difficult and even unpleasant, and Kurita's sales experience led him to suspect that navigating such a new service through various devices might be difficult. The significant development the team proposed was to turn i-mode into an information service as well as a communications platform by including characters not only for users connecting with each other (as they had been doing with pagers) but also for receiving guidance and suggestions from i-mode itself. This explains the presence of advertising and consumer-focused emoji in Kurita's set, such as symbols for the ATM and the convenience store, as well as emoji that helped users understand complex menu options and facilitated the

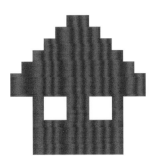

HOUSE

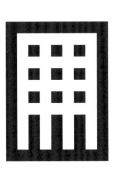

BUILDING

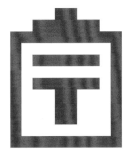

POST OFFICE

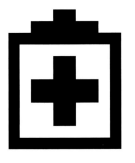

HOSPITAL

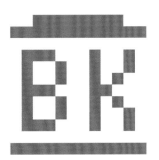

BANK

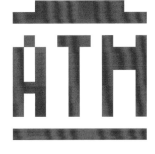

ATM

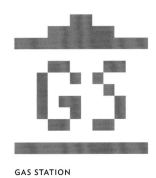

HOTEL

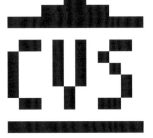

CONVENIENCE STORE

GAS STATION

purchase and use of i-mode's products and services. There were significantly fewer emoji for user-to-user expression. This set of 176 symbols featured only five faces—happy, sad, angry, disappointed, and dizzy—but they proved enormously popular, and remain among the most commonly used emoji today.

Within a tiny twelve-by-twelve grid of pixels, Kurita's emoji had to be both clearly readable on small cell phone screens as well as aesthetically pleasing and appealing to use. The symbols he devised appear simple, but the technology's restrictions presented various difficulties. The even-numbered grid, for example, made it impossible to center emoji, which affected the kerning—the carefully controlled spacing between letters and symbols that is crucial in visually appealing, easily readable text. In addition to reading visually off-center, the symbols were adapted to work at a tiny scale. When enlarged, the tail emerging from the bottom of the heart emoji, for example, composed of two vertically stacked pixels, looks idiosyncratic and unnecessary, but on the small screen of a mobile device, the tail lifts the heart off the grid's bottom line, giving it bounce and liveliness next to ordinary text [**FIG. 11**]. The fog emoji is composed of a diffuse arrangement of horizontal lines that at the intended scale becomes the haze of a misty day; vertical lines, by contrast, would have looked like rain [**FIG. 12**].

Kurita and the i-mode team drew on a wealth of influences, including existing emoticons, kaomoji, and common icons and typographic symbols.

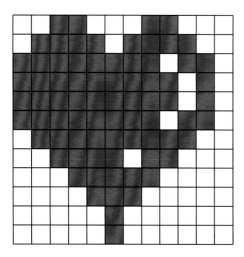

FIGS. 11, 12. "Heart" and "fog" emoji shown enlarged on a 12 × 12 pixel grid and at actual size

Familiarity and ease of use (emoji were selected from a menu and sent one at a time) were of the utmost importance, but the team understood the potential for users to combine emoji with text to add emotional nuance to their messages, such as a smiley face placed next to a lewd remark. The graphic conventions and visual shorthand of manga gave them a lot of creative leeway. In manga, the appearance of swollen veins on a character's face, rendered in a stylized *x* shape, indicates rage; in Kurita's emoji set, the isolated shape, easily recognizable by Japanese teenagers and manga fans, is a shorthand for anger. Nervousness, confusion, and shock in manga are represented by sweat droplets on or around a character's head, and i-mode's initial set of emoji contained two sweat symbols—one rolling down and the other spraying horizontally—to express nerves, embarrassment, relief, and awkwardness. (The descendant of those early symbols, a single, sideways-squirting sweat droplet, has come to imply something far less innocent.)

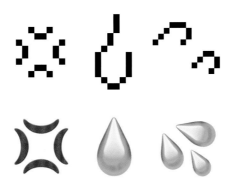

The meanings of various emoji have shifted and evolved over time and across cultures. For example, the manga conventions and other cultural references in the original emoji set were lost on users outside Japan, and some remain obscure for contemporary users. In Japan, an oval shape with three wavy lines rising from it is understood to refer to bathing in hot springs and *onsen* (bathhouses), a common activity; in the rest of the world it is generally employed to indicate heat or a steaming beverage. A wrapped present seems straightforward enough, but in Japan it carries a further association with the intricate rituals of gift giving and *omiyage* (obligatory souvenir gifts brought back after a trip). The red goblin mask (added in 2003 by the cell phone company au by KDDI) depicts not a devil but the mythical *tengu*, an arrogant supernatural trickster.

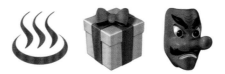

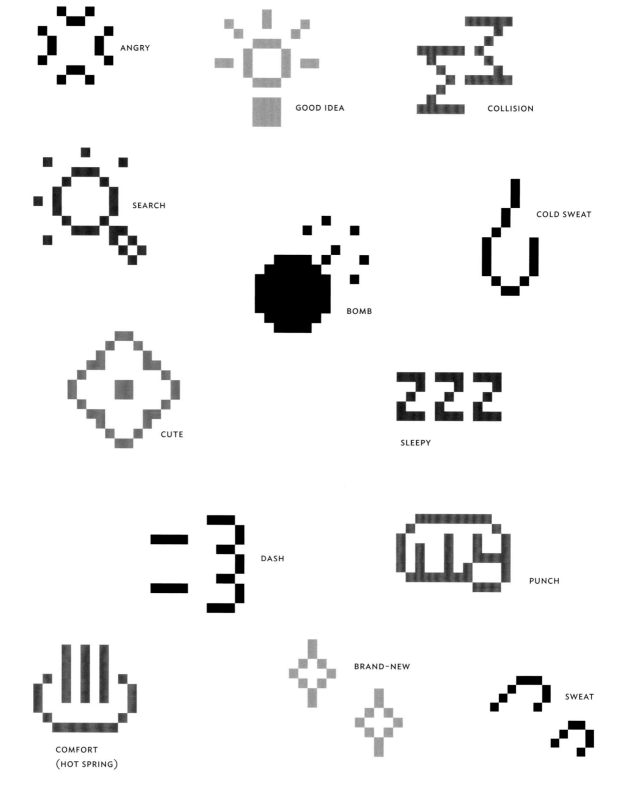

ANGRY

GOOD IDEA

COLLISION

SEARCH

COLD SWEAT

BOMB

CUTE

SLEEPY

DASH

PUNCH

COMFORT
(HOT SPRING)

BRAND-NEW

SWEAT

SMOKING

WHEELCHAIR

RESTAURANT

TRAFFIC SIGNAL

NO SMOKING

PARKING

RESORT

CHRISTMAS

KARAOKE

TOILET

MOVIE

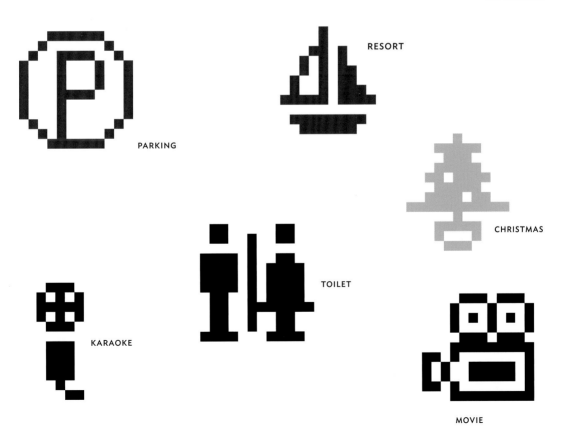

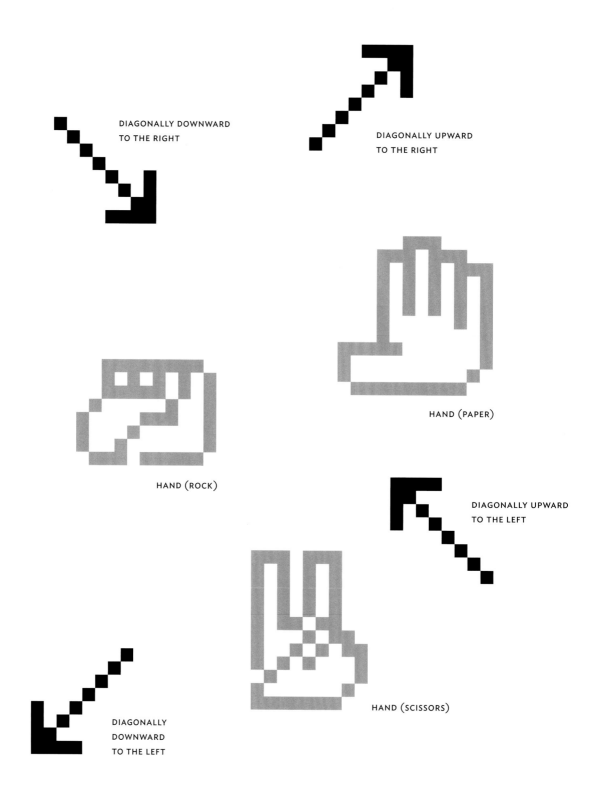

DIAGONALLY DOWNWARD
TO THE RIGHT

DIAGONALLY UPWARD
TO THE RIGHT

HAND (PAPER)

HAND (ROCK)

DIAGONALLY UPWARD
TO THE LEFT

DIAGONALLY
DOWNWARD
TO THE LEFT

HAND (SCISSORS)

Some of Kurita's intended meanings have changed almost entirely. For him, the clenched fist, raised palm, and fingers in a V sign stood for the game Rock, Paper, Scissors, but today they are used to signal solidarity, the "halt" command, and peace.[11] The directional arrows, intended for sharing joystick sequences for video games, one of Kurita's passions, now tend to be used for emphasis.[12] Generational differences factor into conflicting interpretations; while Millennials generally use the smiley face to indicate positive feelings or events, the teenagers and young adults of Generation Z tend to read it as passive aggressive or ironic.[13] Such informal and organic evolution of emoji use, and the variations in how the symbols are interpreted, is similar to the way all languages evolve through borrowing, adapting, and innovating.

In February 1999, accompanied by a massive ad blitz, i-mode and its emoji were launched in Japan [**FIG. 13**]. Within months they were a huge market success, spurring other companies to create rival services and networks. In that cutthroat environment there was little incentive to collaborate, which meant that users could not always reliably send or receive emoji between competing networks. The rollout of conflicting services was fractured and inconsistent, limiting the reach of emoji and other features in the Japanese market.

FIG. 13. Still from a television commercial for NTT DOCOMO's i-mode, c. 2000

Sending emoji outside Japan was even less reliable. The prevailing standards of Internet communications protocols, which were still largely dictated by American organizations, had not been adopted by Japanese networks. The worldwide spread of the obscure Japanese phenomenon was not made practicable until 2009, when emoji were added to the Unicode Standard, the technical specifications that ensure compatible encoding for text, images, and emoji.[14] The consistency of Unicode allowed phones from different platforms to send and receive emoji, although its template allowed some latitude for design [FIG. 14]. The result was (and continues to be) stylistic variety, sometimes significant, between emoji from platform to platform. An infamous divergence took place in 2016, when Apple transformed its pistol emoji into a green water gun [FIG. 15], dramatically changing the connotation of the symbol between sender and receiver. Although Apple's decision was controversial at the time, within two years nearly every emoji set had followed suit, rendering the emoji arsenal much less lethal.

From the humble original heart of 1995 to the ninety symbols on the 1997 J-Phone to the 176 in Kurita's 1999 set, we arrive at today's emoji-rich environment, with bespoke symbols for individual companies and messaging platforms.

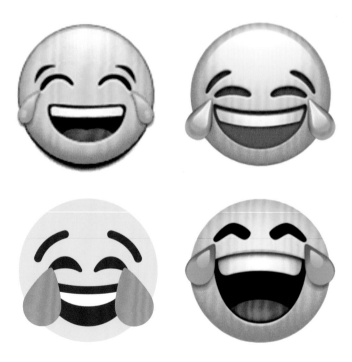

FIG. 14. "Face with tears of joy" emoji for different platforms, 2023.
Clockwise from top left: Samsung, Apple, Twitter, and Facebook

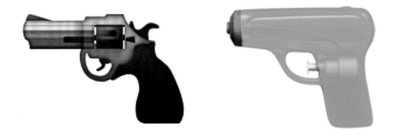

FIG. 15. Apple's pistol emoji before and after it was redesigned in 2016

Today users can choose from more than 3,460 emoji, which they use in mind-boggling numbers. As of April 2023, the most popular emoji on Twitter was the "face with tears of joy," which has been tweeted more than 3.8 trillion times since 2013, followed by the red heart, at 2 trillion times, and the "loudly crying face," at 1.7 trillion. Even the obscure (and obsolete) pager emoji was used 932,827 times.[15] And this is the measure of a platform dwarfed by WeChat, iMessage, and Facebook; on Facebook in 2017, 5 billion emoji-enriched messages were sent every day.[16] In their global use and comprehensibility, emoji have achieved the dreams of Zamenhof and Neurath, facilitating cross-cultural exchange, as well as providing us with a way to assert our complex identities in the disembodied digital realm, in the void left when physical cues and nuance are removed.

The desire for such expression has given birth to other online phenomena, such as the Internet meme, which is the digital expression of Richard Dawkins's 1976 term for information, behaviors, ideas, and cultural units that pass from person to person. Using a basic formula of words overlaid on a still or moving image—often with an ironic twist or absurd contrast—Internet memes have taken the place of inside jokes among friends, the nudge and the wink, a way to lighten the mood. They are perfect for quick posting, sharing, and liking—the very behaviors encouraged by the social media engagement algorithms—and suitable not only for amusement but also for political advocacy, advertising, and the dissemination of propaganda. At the same time, with its inside-joke nature and specific cultural references, a meme shuts out people who aren't part of a conversation, reinforcing the social sorting that naturally occurs in any shared space. In these communities, where members don't have to explain themselves or provide context for the humor, posting the pensive Philosoraptor (philosopher velociraptor) **[FIG. 16]** is a casual, knowing nod to levity, like a quiet snicker and eye roll might be IRL.

SOON

MAIL

ON

PHONE TO

CLOCK

MAIL TO

FAX TO

END

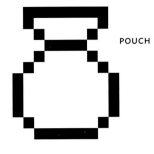

POUCH

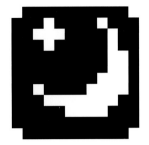

NIGHT

SILHOUETTE

CLAPBOARD

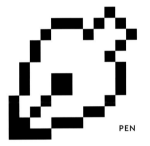

PEN

ACCENT 1

CHAIR

ACCENT 2

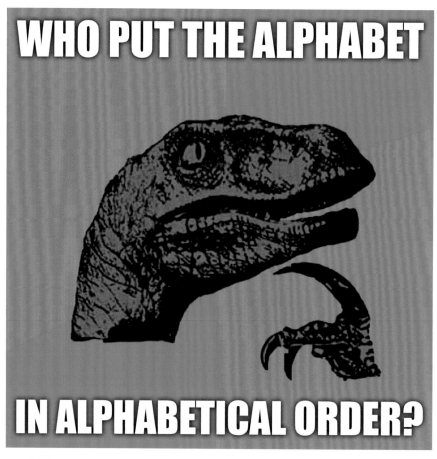

FIG. 16. Philosoraptor meme

A meme is a closed circle of meaning, a joke with an established punch line. In art, on the other hand, meaning is open and oblique and often left to the viewer entirely. The use of text in art can both suggest and subvert clarity, creating distinct feelings of tension and uncertainty, as in Barbara Kruger's work [**FIG. 17**], in which the disjunction between words and images jolts viewers out of their ordinary passive consumption of visual culture and challenges them to reconsider institutionalized systems of power and control. But where art can expose our contradictions without necessarily resolving them, the evolution of a language requires the back and forth of conversation, a process of arriving at reciprocal understanding. Emoji sit nicely between the scripted and the open, offering both the efficient social-sorting humor of memes and the elasticity of art.

Memes and their cousins (animated GIFs, viral videos, and chat-speak) emerged from online culture, shared, altered, distributed, and not owned by anyone. Emoji, by contrast, were created with corporate profit in mind, even as

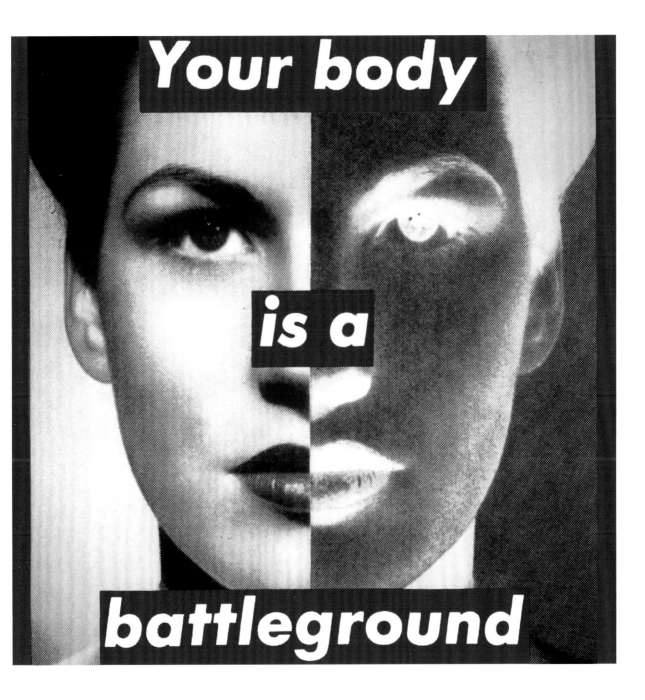

FIG. 17. Barbara Kruger (American, born 1945). *Untitled (Your body is a battleground)*. 1989. Photographic silkscreen on vinyl, 9' 4" × 9' 4" (284.5 × 284.5 cm). THE BROAD ART FOUNDATION

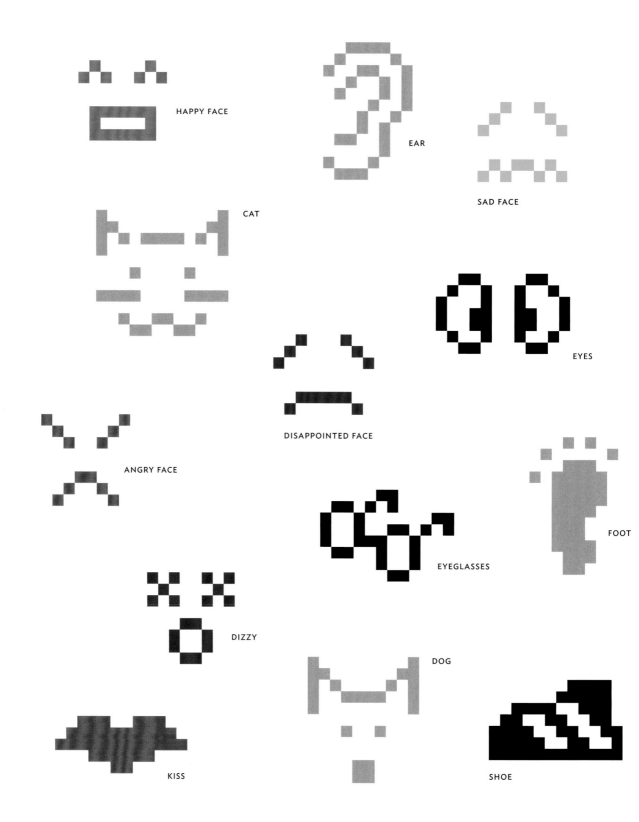

HAPPY FACE

EAR

SAD FACE

CAT

EYES

ANGRY FACE

DISAPPOINTED FACE

FOOT

EYEGLASSES

DIZZY

DOG

KISS

SHOE

they were meant as a communication tool. They were a product to be sold, a service to be tracked and monetized. It is telling that in the period when emoji were contained in proprietary, tightly controlled corporate networks, they remained an obscure Japanese curiosity; it was only when they were brought into the uncontrolled, un-ownable realm of the full Internet did their potential begin to be realized. NTT DOCOMO and Shigetaka Kurita created emoji as we know them, but it is the users who have made them a global phenomenon.

If our digital conversations are to be meaningful, we need the help of gestures like emoji. On the Internet we are bodiless; even the modern wonder of videoconferencing, with its undynamic perspective and awkward cross talk, lacks the creative and personal nature of IRL gestures—the comforting arm on the shoulder, the nervous fidget, the conspiratorial smile. Spontaneity in digital communication is as critical as it is in person: conversation is, after all, something we make. Emoji bring nuance to our online interactions—to sharing moments of absurdity when a weighty situation needs lightening, to conveying compassion or empathy when we hit the brick wall of the inexpressible. It's not surprising that the most popular emoji foreground emotions. The "loudly crying face" provides us with a sign for an extreme state of distress or sadness, one that might well resist words; the "face with tears of joy" stands for a similarly heightened state at the other end of the spectrum. But perhaps it is the heart, the perfect, elastic, and original emoji, that is the most powerful reminder of the human at the center of all the words. A person who laughs. A person who shares more than words. A person capable of that most essential form of communing:

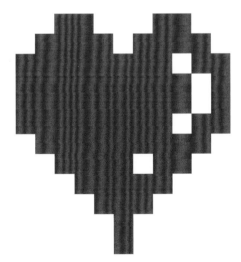

NEW MOON

SPADE

FULL MOON

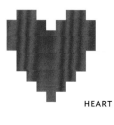

HEART

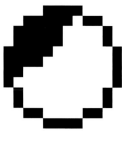

WANING MOON

HALF MOON

CLUB

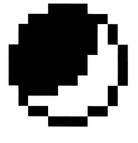

CRESCENT MOON

DIAMOND

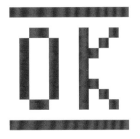

ACCEPT

NEW

FREE OF CHARGE

LOCATION INFORMATION

FEE CHARGING

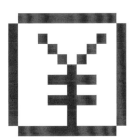

PASSWORD

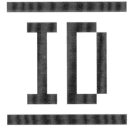

ID

CLEAR

CONTINUING

NOTES

1. The @ sign was acquired by The Museum of Modern Art in 2010, as an example of innovation in the field of interactive design—a symbol of the meeting of human and machine.

2. Ludovic Lazarus Zamenhof, *Dr. Esperanto's International Language: Introduction and Complete Grammar,* trans. R. H. Geoghegan, ed. Gene Keyes (1889; Halifax: Verkista, 2000), genekeyes.com/Dr_Esperanto.html.

3. Otto Neurath, *International Picture Language: The First Rules of Isotype* (London: K. Paul, Trench, Trubner, 1936), 16.

4. These exhibitions include *Signs in the Street,* in 1954; *Word and Image: Posters and Typography from the Graphic Design Collection of The Museum of Modern Art, 1879–1967,* in 1968; and *The Modern Poster,* in 1988.

5. "Why Millennials Hate Talking on the Phone: 'Generation Mute' Millennials Phone Call Statistics" survey, bankmycell.com/blog/why-millennials-ignore-calls.

6. Tim Hornyak, "Defining the Heisei Era: Part 8; Communication," *Japan Times,* December 22, 2018.

7. The 1995 pager also included a clock symbol and a cell phone symbol, but they were seldom used.

8. Jeremy Burge, "Correcting the Record on the First Emoji Set," Emojipedia (blog), March 8.

9. Mari Matsunaga, *The Birth of i-mode: An Analogue Account of the Mobile Internet* (Singapore: Chuang Yi, 2001), 78.

10. Matsunaga, *Birth of i-mode,* 36

11. Shigetaka Kurita, interview by the author, December 30, 2016.

12. Kurita, interview by the author, August 25, 2022.

13. Orla Pentelow, "You've Been Using the Smiley Face Emoji All Wrong," Bustle (website), August 12, 2021. Pentelow cited a 2018 study by the consulting firm McKinsey & Company.

14. Gmail users had to wait until 2008 to use emoji, and iPhone users until 2011.

15. These statistics were true as of 1:37 p.m. (EST) April 25, 2023, emojitracker.com.

16. David Cohen, "On Any Given Day, 60 Million Emojis Are Used on Facebook; 5 Billion on Messenger," *AdWeek* (online), July 14 2017, adweek.com/performance-marketing/facebook-world-emoji-day-stats-the-emoji-movie-stickers/.

FOR FURTHER READING

Alt, Matt. *The Secret Lives of Emoji: How Emoticons Conquered the World.* Self-published, Amazon Digital Services, 2016. Kindle.

Christin, Anne-Marie, ed. *A History of Writing: From Hieroglyph to Multimedia.* Paris: Flammarion, 2002.

Houston, Keith. *Shady Characters: The Secret Life of Punctuation, Symbols & Other Typographical Marks.* New York: W. W. Norton, 2013.

Matsunaga, Mari. *The Birth of i-mode: An Analogue Account of the Mobile Internet.* Singapore: Chuang Yi, 2001.

McCulloch, Gretchen. *Because Internet: Understanding the New Rules of Language.* New York: Riverhead, 2019.

Parkes, M. B. *Pause and Effect: An Introduction to the History of Punctuation in the West.* Aldershot, UK: Ashgate, 1992.

Leadership support for this publication is provided by the Kate W. Cassidy Foundation.

Produced by the Department of Publications
The Museum of Modern Art, New York

Leadership support for this publication is provided by
the Kate W. Cassidy Foundation.

Hannah Kim, Business and Marketing Director
Don McMahon, Editorial Director
Curtis R. Scott, Associate Publisher

Edited by Emily Hall
Series designed by Miko McGinty and Rita Jules
Layout by Julia Ma
Production by Matthew Pimm
Proofread by Sophie Golub
Printed and bound by Ofset Yapimevi, Istanbul

Typeset in Ideal Sans
Printed on 150 gsm Arctic Silk Plus

Published by The Museum of Modern Art
11 West 53 Street
New York, NY 10019-5497

ISBN: 978-1-63345-149-0

Distributed in the United States and Canada by
ARTBOOK | D.A.P.
75 Broad Street
Suite 630
New York, NY 10004
www.artbook.com

Distributed outside the United States and Canada by
Thames & Hudson
181A High Holborn
London WC1V 7QX
www.thamesandhudson.com

Printed and bound in Turkey